The Way of Art

The Way of Art

Stephen Zeifman

Publishers of Singular
Fiction, Poetry, Nonfiction, Drama, Translations and Graphic Books

Library and Archives Canada Cataloguing in Publication

Zeifman, Stephen, author
The way of art / Stephen Zeifman.

Issued in print and electronic formats.
ISBN 978-1-55096-612-1 (paperback).--ISBN 978-1-55096-614-5 (EPUB).
--ISBN 978-1-55096-616-9 (MOBI).--ISBN 978-1-55096-618-3 (PDF)

1. Art appreciation. 2. Zeifman, Stephen--Anecdotes.
I. Title.

N7477.Z45 2016 701'.1 C2016-904910-8
 C2016-904911-6

Design and composition by Michael Callaghan
Cover photograph, Delacroix's Garden, Paris, by Stephen Zeifman
Typeset in Garamond at Moons of Jupiter Studios

Published by Exile Editions Ltd ~ www.ExileEditions.com
144483 Southgate Road 14, Holstein, Ontario, N0G 2A0
Printed and Bound in Canada in 2016, by Marquis

We gratefully acknowledge the Canada Council for the Arts,
the Government of Canada, the Ontario Arts Council,
and the Ontario Media Development Corporation
for their support toward our publishing activities.

Canadian Sales: The Canadian Manda Group, 664 Annette Street,
Toronto ON M6S 2C8 www.mandagroup.com 416 516 0911

North American and international distribution, and U.S. sales:
Independent Publishers Group, 814 North Franklin Street,
Chicago IL 60610 www.ipgbook.com toll free: 1 800 888 4741

To Jack and Olivia

The Way of Art

What it means to live with art. With artistic practice, with history, with theory. Eyes and mind opened to visual and intellectual experience. What that dimension brings to being alive, being human.

How the experience of art enhances the quality of life. Knowing about art, being open to the experience of art, being able to take pleasure in looking at art.

1

What does it mean to have skill and understanding in visual art? Does it mean drawing accurately, expressing feelings and ideas creatively and competently with a variety of media, being interested in and coming to understand the work of others? It is all of these things—while learning through practice and experience to see, analyze, examine, take risks, and develop confidence while relieving stress and finding personal harmony and balance.

There are no tricks to achieving this competence. There is only practice and persistence. Drawing, for example, is a physical skill involving hand and eye coordination that can only develop over time. It is about seeing clearly, about trusting what the eye sees and ignoring what the brain wishes to see. There are methods and techniques for building form with shadow and light that are made more understandable through observation, practice and experimentation with various media like charcoal, graphite and conté.

In over thirty years of teaching art there are principles I have come to believe are essential to developing the skills required to produce visual art. It is a natural process. Look at the drawings in the Lascaux or Pech Merle caves, look at the rendering of the animals on those walls that are over twenty thousand years old. The artists, creators of those images, did not go to art school.

What they did was step outside and take a good look at the animals they were about to hunt with rocks and sticks and spears, their sole source of nourishment, and they had to understand the animal, had to see it clearly to be able to defeat it. In part, drawing it accurately before the hunt gave the hunter the sense of owning the animal and not fearing it. It gave the hunter the confidence to approach the bull or the woolly mammoth and attack it. In modern practice people often gain control of their personal demons through the practice of drawing them. Wake up in the morning and draw that shark that has been attacking you in your dreams and waking you out of a pleasurable sleep and you will feel you are larger than the shark, and its power to frighten you will diminish.

Here I might say that an artist is someone who never loses a sense of the power of the symbols he or she creates. So many of us lose that sense around age six or seven when suddenly the circle with two dots and a crinkly line is no longer Mommy and we look with envy and longing at the precocious child beside us in class whose drawing looks more like a photograph. We want to do that too but can't because we need to practice doing it and there might not be time in school or motivation outside of school or support for pursuing the practice. That kid who can instinctively draw well is like the kid who can sink baskets or serve and volley in tennis or do lovely pirouettes on figure skates or hit a fast pitch or bend it like Beckham in soccer. But does the fact of others' skills in sports stop people from playing, and through their

play becoming ever more skilled themselves? What is it about art that at such a young age the perception of someone else's superior skill is enough to turn a child off for life?

This book will address that: the fearful, insecure child, the child who wants everything to be perfect and when things aren't perfect abandons the pursuit or the practice of the means of expression. It happens with music as well, on the piano or the violin. Those fears about expression, about doing it wrong, about making a fool of ourselves, haunt us for life. Sometimes reengaging with artistic practice and finding pleasure in the pursuit is as simple as confronting that child and asserting the reason and power of the adult we have all become.

2

The first marks we made with pencil or crayon when young, say two or three, were gestural and spontaneous and gave us a sense of fun. They were also an extension of the self, something tangible we made that existed outside the self. Soon the tangible spontaneous marks became symbols that we believed were true representations of mother, father, house, flower, sun, cloud, boat, car, dog, cat, and tree. They were the things that made up our world, the things that were in closest proximity to our experience. Our drawings had very little veracity or accuracy as renderings but we believed in them nonetheless. Remembering that an artist is someone who believes in the power of the symbols he/she creates, as children we are all artists. But in time, a short time really, some of us stop believing that our marks represent anything and begin to see that to draw accurately requires a special skill that most people do not possess. From my experience there is no truth to this. Drawing accurately from life can be learned by most. It is a matter of practice and eye-to-hand coordination. What can't be learned is the belief in the power of the marks made on the page.

To draw accurately from life is to translate three-dimensional form into an illusion of mass, volume and detail composed of markings on a flat or two-dimensional surface. The first requirement in drawing accurately from life is seeing the subject clearly.

Representational drawing requires a cool analytical, thoughtful, and interpretive gaze. This is where the process starts, with the gaze. And the eye follows the form and the hand follows the eye. And through the marks the hand makes the true nature of the artist is revealed. Passion, desire, clarity, uncertainty, hesitation, tentativeness, discipline, focus, rigour, laziness, inhibition, intelligence, playfulness, and so much more flow through the hand onto the page. Drawing is one of those activities that will take everything a person has to bring to the act, and at the same time make obvious what is left behind.

Graffiti is a different kind of drawing. Graffiti is big and bold and often brave and in-your-face and its purpose is to solidify an identity for its maker. It is not about the representation of an external form. It is a way of representing the character of the maker and gives the maker a means of expression. Many artists make marks on surfaces that are abstract and about the marks themselves and not what the marks capture or represent. Cy Twombly and Sol LeWitt come to mind. Others give form to images in their imagination creating a personal iconography like Munch, Marcel Dzama, Picasso, Arshile Gorky, Philip Guston and many others. And some, going all the way back to cave dwellers on up through da Vinci and Michelangelo, Ingres, Millet, Van Gogh, Wyeth, and Pearlstein and a thousand more, try to capture what is before them.

There are ways to learn how to do this. It is the capturing of a perceived reality that makes sense to most people. This ability

has purpose and value. Anyone, people think, can make random marks on a surface but few can really draw; that is, make something on the page look real. Real, as in it looks like a photograph. What a photograph does is capture the light reflected from the surface of a subject the camera is pointing at. What some artists —the earliest being da Vinci—figured out, is that by capturing the shadow in a form and the light emanating from that form, an artist can create the impression of verisimilitude, can create an image that looks real. The technique is called 'chiaroscuro' and you can see it in the pencil studies da Vinci did of the babies in *The Virgin of the Rocks*. Can you learn to draw like da Vinci? Probably not. It would be like learning to play tennis like John McEnroe or golf like Tiger Woods. But you can learn to make an image that looks real, that has a degree of verisimilitude. You might even learn how to pronounce verisimilitude and use it in a sentence. Just follow these simple steps and practice for one hundred hours.

Drawing is really the beginning. It is the thing everyone wishes they could do but few people believe they can do, and it is the thing most people give up on early in their lives and never return or try again. And when people give up the practice of art many also lose an interest in the works of others as well. Why is this? No one wants to do something that makes them feel terrible about their lack of skill or grace or comprehension. But drawing is so accessible, so close at hand so to speak. All you have to do is reach for a pencil. It is interesting how millions go through life

avoiding this at all cost. Is there a drawing equivalent of singing in the shower? Doodling perhaps while on the telephone. Though now, with people texting so frequently, their hands are not free for even this type of fundamental mark making. Let's say you want to learn to draw. What should you do?

You could join a class at an art school and begin work with the figure, the foundation of all representational art. Joining a class has the advantage of a structured approach to learning and feedback from the instructor, so the process is not one of hit-and-miss and randomness. A class takes place at a regular time and this will get you involved in the process with some consistency, and will offer the opportunity to do work on your own between classes. This practice is necessary, like practicing an instrument. Though it seems so direct and readily available and is something humans have been doing since the beginning of time, achieving sophistication and skill is challenging and requires hard work. There should be no notion of creating masterpieces or of even making *art* when beginning the process. Drawing classes that work have a wonderful atmosphere. There is the sound of pencils graphite sticks or charcoal being dragged over the paper and each participant has a different touch and the sound can be almost musical. For the most part the process demands total concentration so there is little conversation but the intensity of the concentration in the room is palpable. And then there is the model, nude or draped in fabric, reclining or standing, who is the focus of everyone's attention, yet the model is lost in his or her thoughts.

Usually the figure is lit to produce contrast—light and shadow—and the lighting gives the room atmosphere. Some groups like music, others don't. There are opportunities to take life drawing classes without an instructor. You just show up at a given time with your materials, and there is a model that all the participants pay for. This is a good situation once you have had some experience, but there is nothing like learning from an instructor who guides you through the fundamentals of the practice, and does so in a way that is encouraging, enthusiastic and supportive of your desire to learn. You don't need a cynical instructor who is only putting in time for the money. Most likely that will chase you back to point zero and may even make you think it ridiculous to want to learn in the first place. We all had terrible art teachers in our youth, the ones that insisted everyone in the class draw the tree in exactly the same way. Often it was the instructor's way, and the challenge was to copy their style and face blunt, discouraging comments for showing an inability or, really, a lack of desire to copy the work. As an art teacher I never demonstrated how to draw or paint, never demonstrated how to render from life, knowing students would want to copy my style rather than allow themselves to approach the problem with their own rhythm. Of course I demonstrated techniques like how to use paint, or mark a plate and make a print, and all the hundreds of things covered over the course of a four- or five-year art program. When there was a model in front of the group, everyone exhibited a different touch, and though most were accurate, no two works looked the same. That

was the intention. Learn to model the figure seeing shadow as shape and building from there. You say this to a group and it is a viable approach and each person tries it and the work has some sensitivity and sophistication but each one is different. The touch is like a fingerprint or a signature. Every great artist can be recognized by the uniqueness of their touch even though they all might be drawing a standing nude. Each beginning artist has an instinctive touch but must learn to see and recognize shape, form, proportion, detail, light and shadow, and the movement of tonality across the picture space. If the touch is reticent and shy it must be made bolder and more confident, but still it is the individual's touch that is being developed. It is complicated because there is a vast language to be learned, a complex vocabulary of technique, and each person has to learn these things while at the same time retaining their individuality. That's why there are no tricks, no short cuts to excellence. Every subject makes its own demands on the person drawing and it would be pointless if each person was dividing that figure in sevenths and marking it with the same crosshatchings and thinking: "Yes, I have made something that looks like a drawing" but without seeing and analyzing the problem, the individual problem; without recognizing the specific nature of the problem, of the subject, and capturing those specifics. Without all that, the next drawing, done with formula or generic tricks, will look more or less like the last and rapidly the will to learn that is driven by the desire or the need to solve a problem will dissipate, because the problem will disappear into the fog of formula.

3

I was a poor student, one who took instruction badly, one who had trouble conforming to anything the group was doing, who resisted following the rules. This made learning difficult. I took typing and failed. French the same. And art. It was Mr. Thompson who killed it for me. A sardonic Englishman with no understanding of how children learned and who was bitter about his own art career that had him teaching at the junior high level and resenting it. He probably drank too much after class. There was no encouragement or kindness from this man, just poor marks—Ds and Es for what? For improperly copying the tree in the painting. I dropped art after that and looked at it longingly from the outside, knowing there was a party there that I wanted to attend, but finding entree was difficult. On occasion I visited art galleries and museums, and later had a girlfriend in Buffalo, New York who introduced me to the Albright-Knox Art Gallery and its remarkable collection. It was cool to go with this girl to the gallery. There was cool stuff there. A room of mirrors with infinite depth, kinetic sculpture, Gaugin's *Yellow Christ*. I knew nothing about art, classical or contemporary but I knew what I liked. In time, after my first trip to Europe at age twenty-one, that was no longer enough. There was a world I knew nothing about and it was this world through which I was moving, sometimes very quickly on a motorcycle that trip, but it

was provocative, challenging and stimulating when I was standing still. Churches full of paintings, museums full of paintings, sculpture in the squares, buildings of all shapes and sizes and with the power to move the spirit. What was the story, where did this all come from and how did it connect with Kandinsky and the Clyfford Still at the Albright-Knox? When I returned from Europe I added art history to my English major at the University of Toronto and in the end, after two more years, graduated with a double major in English Literature and Art History. I loved art and wanted to be a writer. Studying art history was the first time I achieved any academic excellence in my life. It was simply because I liked the subject, was highly motivated to learn, spent most of my time reading about and looking at art. In art history I got As. In the study of art history I befriended some of my professors and this helped open up my university experience. I wanted to practice art as well but I had the demon of Mr. Thompson telling me to forget about it, I would never amount to anything, so I wrote creatively and continued to absorb what I could of art and art history. It was so exciting for me to open a door to this vast kingdom, to be seeing and experiencing some of the many facets of it beauty and history and to be learning something of how it came to exist. There was so much pleasure in looking at art, in just seeing it for the first time.

That was the beginning for me and it has never subsided. I go out and spend a day at an art museum and come home feeling exhausted from the pleasure of seeing and the discovery of things I

had previously missed along the way. The work is there for all of us, the architecture, the art in public places. There is a history dating back thousands of years and all that is required is some initial curiosity to want to see and understand this essential dimension of human endeavour.

Now when I sit down to draw a pear I think of Cézanne and the first time I understood what it was that he was doing. It was at the Barnes Collection touring show at the Art Gallery of Ontario. I was walking from room to room and looking at some wonderful work by Manet, Monet, and others of their time in Paris when I turned into the room of Cézanne. In that room there was no other artist represented and I felt like I had stepped into a place of an alternative consciousness, a room of works by an artist who thought about painting differently than anyone ever had. There were other great works in the show but there was something familiar to me about them. The Cézanne works were different. There was something essential about them, fundamental, something that said the artist was not sitting down to paint a pretty picture or make an accurate rendering. He was stripping away the gloss, the things that distract from seeing the truth of what one is beholding. The objects in his paintings were absolutely solid, dense, had weight but were not photographically accurate. The apples were apples you could imagine picking up and rolling around in your hand but there was no shine to them, no distracting accuracy or illusionistic representation. You could compare them to Fantin-Latour, a contemporary of Cézanne and the brother-in-law of

Manet, no slouch himself when it came to representation. Fantin-Latour's work was wildly popular and people were seduced by the illusion of reality in his paintings. Cézanne was not popular and the "thingness" of his elements bothered people. He was like Van Gogh in this way, dealing with essential truths. A Van Gogh iris was like no iris anyone had ever painted. You could smell it, feel the powdery softness of the petals drooping with the weight of being well watered in the height of the growing season. There was a palpable reality to Van Gogh, one without sentiment, which no one liked until about twenty years after his death. The intensity of his gaze made people uncomfortable. Cézanne wasn't doing that. He was reducing his reality to its essential form and what he was painting was the form as he saw it. Each stroke of his brush was like a brick in the building of the form he was observing. His apples had weight, but did they have flavour or perfume? Or were they simply the thing that occupied the space before his eyes? By that I mean the thing itself, the shape and weight of the thing itself, not romanticized or idealized and anthropomorphic in execution. As he evolved this vision, this approach, he reduced all form to its essential components. And it is this reductive approach that earned him the title of Father of Modern Art. Modern art was all about the reduction of things to the essence and quickly, from Cézanne, this led to pure abstraction in painting. Abstraction being about form and colour and composition, the foundation of painting, but without recognizable elements. It was painting about painting and not about painting a person or a horse or a vase of flowers.

Art is there for the looking—like the sky and the trees and the ripples on the sea. Some knowledge of art history helps to give the vast world of art some context or structure. It begins to feel like a villa or a castle or a village that can be explored and known and once known, a place to return many times with a feeling of comfort, a feeling of being welcome and being at home and not one of intimidation and fear of the unknown.

Looking will help you see.

We become visually lazy living in big urban centres and we teach ourselves to stop looking, to make no eye contact, to not appear to be staring. Riding the subway is an experience contrary to so much of what it can mean to be human. In the urban centre other people are potential threats and one must be alert to danger at all times but one doesn't want to invite danger by making eye contact with the wrong person and in fact one doesn't want to invite a friendly exchange with a stranger either, so the gaze is inward and on the floor or the ceiling. How uncomfortable it is to ride amongst people and try at all times not to have any contact with these people whatsoever. Then out on the street there is concrete and buildings, few of which have any aesthetic dimension, and regardless are all familiar from years of walking the same streets to work or home, and so the glance is down to watch your step and not much else. The attempt to not see, the habit of not seeing, the effort exerted to not see or not even look, takes its toll and requires work at the visual gym to overcome.

4

Creativity is unruly. It is a potent force that cannot be trusted to do the right or appropriate thing in a given context or situation. It is like that wild and uninhibited kid you knew in school who you always wanted to be friends with, and when you brought him home for dinner one night he drank too much, puked on the carpet and knocked over a lamp. Your parents were upset and you were asked not to hang out with that person again. That person lived in a house where people wrote and drew on the walls, ate at odd hours, and slept only when they were tired. No one seemed to have a steady job but there was always money around and people were not worried about the future or making a good impression.

Creativity follows its own rules. Creativity cannot be boxed and marketed as a stable and predictable entity. Organizations that want to run on creativity, as the fuel that drives the place, cannot usually sustain the energy unless there are no protocols and common practices that have to be followed. People allowed to work freely will often step out of the strictures that hold a company together. There can be no half measures when engaged in a creative process.

Creativity is the spirit, the realization, the revelation, the *satori*, that those following the way of art hope to achieve.

There are so many barriers to most adults achieving a balanced state of creativity and recognition. To think, "I can do that, I can make a mark here and there on this piece of paper and draw that face this way," and not worry or be concerned about the way anyone has drawn that face in the past and then to feel in control, yes in control, of that small universe that is opening up on that surface, is a difficult thing to accept and take in and incorporate in subsequent behaviours.

Of course the whole question is complex. The whole world of art, the history and practice, is complex and full of contradictions. Most societies value the artifacts made by the practitioners, the craftsmen, the artists, the mystics, the shamans in the culture. There are the makers and the observers. The makers usually are observers as well, having a good idea of what other makers have made in the past and are making in the present. The observers, the participants in the experience of looking, of seeing, can derive great pleasure in that practice. The pleasure intensifies with the breadth of knowledge and understanding the observer brings to the experience of looking. We can all find pleasure in seeing the sun set over a lake in mid-summer with the riot of violet and orange and the still water and the fresh air and the peace of mind at the end of a day in nature. We don't need to train for that experience, but we do need to be open to it. It is more difficult for most people to take the same pleasure in looking at a painting in an art gallery, or a sculpture, a drawing, a print, a photograph, or a building. We have not been trained to look at these things with

a sense that pleasure, understanding, a tickling of the spirit, is the reward. In the same way we were not trained, in school, to read for pleasure. People learn though, to read for pleasure and for escape. Pleasure is in the escape. Pleasure is in the language and the composition, the organization of that language into a satisfying narrative or a puzzling poem. We are less intimidated by a book than a painting. More people will reach for a book than get out and go gallery-hopping or visit a museum for the fun of it and not because it is on the itinerary of a trip.

Why? Fear. Intimidation. Ignorance. Conditioning. Bad associations. Boredom. Unsatisfying past experience. But the rewards are great. Can these obstacles be overcome? How?

There are processes that are not literally creative. Representational drawing for example. Which, when you get right down to it, is the one thing most people would like to learn how to do. Like playing the guitar or the piano. It requires focus and concentration and practice and the capacity to sit in silence hearing only the pencil scratching the surface of the page. In choosing the poses or working with the model or selecting items for a still life the person learning becomes creative. Perhaps the sensitivity involved in drawing well, the ability to transcend the self and give the self over to the subject; perhaps that is a creative process.

It is interesting to see people accept and value creative work when they are people that normally gave it no value, personally or societally. But perhaps that is not true either. A guy makes a wooden chair in his workshop or a bird feeder or collects antique

artifacts related to the job he once did as a linesman and finds beauty in the objects and this is a guy who wouldn't recognize an artist as having any legitimacy as far as being a contributor to society, or as doing the kind of work that garners respect. But this same guy can be moved by a photograph of his environment, a photo showing it in a way he has never seen or noticed or paid any attention to. And with time and frequency of seeing, the creative work begins to have currency in the culture that shunned or ignored it. The guy might then think there is creative value, personal value, to the object he concocts in his workshop. It will be years before this person accepts or responds to any abstract imagery but that is something else again. Through practice and having some discussion and support, this person might want to develop other less pragmatic skills than woodworking. Drawing perhaps, the making of something real with a pencil and paper. The leap has to be in the suspension of disbelief, in being able to recognize the substance of the representation, the personal value of engaging in the process, the capacity to see the subject of the drawing as an alternative to the subject drawn, to see the power in the drawing. This all takes time. The mind can be nudged open along the way if the environment for learning is not threatening, and if over time there is progress or development in the quest for advancing skill and if, as happens sometimes, there is competition, friendly competition, amongst the participants and one takes some pleasure, or pride, in seeing their work as better than a fellow participant's work.

5

The Mill Road Studio, the building itself, is a lovely, well proportioned structure that sits on a hill overlooking the Atlantic Ocean on the east coast of Newfoundland in a relatively remote area three hundred kilometres from St. John's, the oldest city in North America. The building takes full advantage of the natural clarity of the light, with a number of large windows and two doors. The building sits on a north-south axis and is infused with light from dawn to sunset. There is a stove for heat and a fan in the peak of the ceiling, twenty feet high, that can distribute heat more or less evenly throughout the building. The walls are rough, revealing the way the building was constructed, and canvases can be hung on nails hammered into the vertical supports. The floor is wood and there is a sink, a laundry tub, for washing brushes and other implements. All in all it is a casual, inviting space, where a person coming to the program would not feel constrained or worried about making a mess with whatever materials they were using. There is a model stand and a backdrop can be hung to help define the figure in the space. Wooden stools and tables made of planks resting on sawhorses are the primary furnishings in the building.

Newfoundland is about four hundred and fifty miles out at sea off the east coast of the Canadian mainland. There are two ferries: one is a six-hour voyage and the other is fourteen hours.

The six-hour ferry leaves the traveller about ten hours by car from the Mill Road Studio. The fourteen-hour voyage leaves a two-hour drive. The traveller can fly to St. John's and then rent a car for a three-hour trip or hire a taxi that runs regularly from the airport to Bonavista, a town located where John Cabot first landed in 1497. I am telling you this to illustrate that getting to the Mill Road Studio involves travelling quite a distance, and it is a distance not only in miles but from the comforts of big city life to a rugged rural situation, with certain amenities, but one that is located right on the eastern edge of North America.

The program at Mill Road Studio has been developed as an art program that can help anyone, from the absolute beginner to the professional, expand their skills and comprehension of the process of making visual art. But it is also a transformative experience that has art practice as a foundation that can inspire and support a shift in perception and awareness. This is possible in part because of the remote setting and the lack of distraction that comes with being far away from work and the family home. The location, essentially out at sea, provides for variety and unpredictable weather. There can be fog and rain and wind and warm sunshine and clear skies and dramatically cloudy skies and T-shirt warmth to parka chill, and this can all happen over a few days in July. This coupled with the stunning physical environment—with its rock cliffs jutting straight up from the sea, and the clusters of forest, and the rolling hills and the wild flowers, and the ever-present vista of the sea stretching as far as the eye can see—

help a visitor shake off the tensions and concerns of their regular daily lives. The physical situation of the studio and the surrounding area imposes itself in a way that leaves little room for defence. It may not happen in the first few hours but it does happen after a few days. The physical environment inspires awe. Combine this with poor cell phone service and a program that is free of technology, and a visitor can rediscover the quiet places in themselves that may be lost to the rigours and demands of being a professional in a competitive urban culture.

The Mill Road Studio program covers some fundamentals of drawing, painting and printmaking. So far these are in the realm of working from life or the landscape, but the participant can bring whatever nuance of personal expression and creativity to the work being done. There is a three-hour session in the morning from nine until twelve and then lunch is served in the house at a long table with a stunning view of the coastline, the sky and the sea. After lunch there is another three-hour working session but not all of the time is spent in the studio. There are some outstanding trails in the area and hiking these trails is an important part of the program. It helps to get the participant to live in the moment and to engage in something for pure pleasure and excitement that is not about an outcome. Walking the trails and then stopping along the way, once or twice, with a sketchbook allows for the possibility of the participant connecting more fully with the landscape than if they were just ticking the trail off a to-do list and taking a few pictures along the way. The rhythm of the walk

is like the rhythm of working in the studio with a life model or a still life installation. To gain the most benefit from the experience it is essential to be able to immerse in the process at hand. This is a difficult thing for many people to do but there is something about being out there on the edge that encourages this immersion in a more natural way than, say, going to a meditation class in the morning on the way to work. Losing sight of the worries and stresses of daily life, even for a short time, even for a couple of hours or a few days, allows for some personal renewal, a revitalization of the spirit. Add to this the pleasure to be had in making something new, something that demanded the learning of technique once thought to be out of range, and the feeling of confidence brought by this kind of achievement. The participant often experiences a sense of well-being and a renewed desire and determination to break the restrictive habits that have formed over time.

6

Painting is more than capturing the external world as you see it. You can never capture the external world in pigment as you see it. Pigment has properties of tonality and texture that are dissimilar to what is purely seen. Painting, then, is a way of interpreting the external world and organizing it in a way that pleases the painter. There is much about painting that has to do with the organization of shapes, form, in the picture space. Magritte's famous painting of a pipe with the words CECI N'EST PAS UNE PIPE (this is not a pipe) holds the essence of painting. His pipe is a symbolic representation of a pipe, a two-dimensional pipe in pigment. All representational painting is symbolic. All representational painting is two-dimensional pretending to be three. It is an illusion of three dimensions and there are techniques, even tricks, painters master to create this illusion. The marks an artist puts on the surface resonate for that artist. Some need to be thinking about the actuality of what they see and struggle to make marks that best represent that. Others use what they see as a jumping-off point for a different kind of expression. Think of Picasso's paintings of women, women who were his wives and girlfriends. The images represent his fluctuating emotional response to these women. Some days they were lovely and representational and other days they were hideous and

expressive—but always interesting as painting. Other painters saw only the world they were creating on the surface on which they worked. These artists organized pigment and form to create a world of their own, and this world had to conform to their vision only. This is what abstraction is, essentially. A way for an artist to take control of the flux of life and create a situation where there is some kind of personal logic and order. It is the ultimate creation and makes the artist the master of his or her own world. This I think is what takes hold of people and compels them to paint. It is this sense of being in control of something: the pigment, the form, the space, the texture, the emotional resonance and dimension of the piece created, and the opportunity to invent and do something original. It is not easy and the longer one works the more challenging it becomes, but resolving the greater challenges brings with it more of a sense of reward. Then there is the notion, of great importance to artists, that the public is taken with or attracted to the work and is willing to spend money to own that work and have it hang where they live. There might be some universal truth then in the rhythm of the marks made by a painter of abstract pictures that is attractive to the viewer and draws the viewer to it and in a sense orders the views of a chaotic world as well. The loved piece might act as a mandala and bring a meditative peace to the viewer each time they stop to regard the painting on the wall. All the works a person might buy contribute to some overall feeling about the space in which they live or work. With representational work people judge it

according to their estimation of how accurately the work represents the world they know. Van Gogh did not sell a painting in his lifetime. He was an outstanding painter. One of the best who ever lived. His work had power and stripped away the gloss of calm reality. His work was rich in tone and texture and looked different than what people had become used to seeing as representative painting. His work offended people and it most likely disturbed them with its intensity. Van Gogh was like the brilliant friend with whom you could only spend time on occasion because conversing with him was so intense, and he didn't ever self-edit or hold himself back. His paintings were like this when first seen but in time the viewers were more accustomed to various artists' work with paint, with the obviousness of paint, with the idea of making a painting that looked like a painting and not making a painting that looked like a photograph, and the viewers numbed by the complacency of the infinite repetitions of the classics needed something to arouse them. Twenty years after his death, Vincent van Gogh was beginning to be recognized for the work that he had done. Most great artists are visionaries. Art stems from the unconscious. Dreams come from the unconscious. Dreams often anticipate things the dreamer has yet to recognize in their daily life. Painful things. Things already in motion that exist only as undercurrents to life. (You dream of fighting with a spouse or a close friend and of the relationship coming to an end. Six months later this fight occurs and so does the breakup.) Artists are dreamers. Artists see what people around

them don't see. Artists are looking in ways that others don't look. Artists tap into the zeigeistzin advance of others. Artists are the advance troops, the scouts into the way the world is going. Van Gogh was too rough for his time but perfect for the twentieth century.

Knowing these things or thinking about them, or thinking about the direction one has taken in life, and recognizing that something might be missing—and that that something might be the need to create, to order, to make tangible, to produce work for the sole purpose of becoming immersed in the process— would be a beginning point in seeking out instruction on how to handle the materials with a degree of competence.

What do you want to paint? Or can you even know that until you pick up a brush and begin working on a little still life or a figure study, and see the form take shape on the canvas or the paper?. You might only have the vaguest notion that you would like to paint and then once you start you might then find you are painting images different from anything you had imagined for yourself. The medium is the message. The medium and the process leads you to discovering what you are concerned with or what satisfies your need for freedom of expression. Freedom is the word really. When you are working at this you are free from the constraints that bind you every day. You are alone and solving a problem you have set for yourself. There is no boss, no art police; there is just you and the material at hand.

7

Perseverance, tenacity, flexibility, the ability to make mistakes (and learn from them), determination, drive, resourcefulness, creativity, focus, concentration, and physical coordination are some of what is needed to get good at art. There are no shortcuts to success. I used to say that to my students. The work of art was the most revealing work in terms of how it reflected the effort that went into producing it. It is like, and I hate to use this allusion, golf. Learning to play golf and achieve a level of expertise at golf is like learning to master certain artistic practices. Why bother? Personal gratification. Escape. Balance and inner peace. These are not things usually associated with golf. Inner rage and frustration. Different kinds of people take up the different challenges. Getting good at art requires a great deal of time and leaves no leisure time for golf. Getting good at golf requires most leisure time spent staring at a little white ball and smashing it with a metal club (except for the putter) and hitting it as far as possible. Though there is eye-to-hand coordination and the proximity of nature, there is little focus on visual aesthetics. I've tried both golf and art. Visual art has been a constant; golf is something that can be left on the shelf for years at a time. The beauty of golf, though, is in the fleeting nature of the experience. A perfect stroke of the club and the perfect trajectory of the ball deliver a fleeting

euphoria. You are only as good as your last shot. The student of art, though, has a trail of tangible results which can be appreciated over and over for years.

That may have more meaning than seems obvious. Many artists, writers, composers, sculptors, architects, have an awareness of what they are leaving behind, and what they leave behind holds the idea of immortality. Creative people seek immortality through the work they make.

Golfers seek escape, and then there are the drinks afterward. For the artist and the writer, the sculptor and the musician, there are also drinks afterward. These drinks have taken the life of the creative person. Creative output is physically and emotionally draining and leaves a void that alcohol soothingly fills, nourishes and replenishes. Golf too leaves a void and alcohol numbs the existential scream recognizing the irretrievable time just wasted out on the course.

I might be kidding. Running with an idea, riffing on the sound of the words, is the fun of allowing yourself to be creative. It is better to work big and get everything out on the page than to work tight and small and imagine producing finished work right out of the gate. Let those drawn lines flow off the page. Let the model be heavy.

The sculptor works rough and broad finding the basic shape before revealing the fine detail of what he sees trapped in the wood or stone. A drawing can evolve like that as well.

8

The way of art is a way of life, incorporating art in many different ways from appreciating it to making it. Who chooses the way of art? Think about *The Way of Zen* by Alan Watts.

What is it about Zen that was and remains attractive to offspring of the middle class, consumer-driven-materialistic-ever-striving for success and financial reward, leading to misery, frustration and marital discord? That pretty much answers the question. Zen is the antithesis of this way of life. Zen is the opposite. Zen is the antidote. Zen might be the cure. Is there something inherent to Western culture that can also serve as an antidote to the existential emptiness of this way of life? Art in its purest form.

The practice of art, immersion in the process of doing art, immersion in the history of art. It is not a religion but a body of experience and knowledge that has been with mankind since the beginning, and to know it can absorb a lifetime of study. What's to know? I know what I like. Experiencing great art can be transcendent, like meditation, an immersion in the complexities of human expression and beauty. But these transcendent works are difficult to locate and even more difficult to recognize without some understanding of what lies beneath the mere surface of the work. Some beauty, it is true, is only skin deep. The fresco on the ancient wall fading, chipping, peeling, worn down by time, the

wall itself, the ancient building, the road it is on, the village in which it resides, can all be beautiful. What took you there in the first place? And did you have any idea of what you were looking for or what you might find? It is a language as old as society, as old as people living in groups, and there is much to know. How long did it take you to paint that picture, Picasso? My entire life. You can't learn to speak Mandarin in a short time. Why do you think you know about art? All Picasso, all the time. So much to appreciate, so much pleasure to be had, in the work of just one man, one difficult man, one not interested in creating conventional beauty. One man who made something every day throughout his long life, a force of creativity, a brilliant mind with skill to rival any of the great masters. When I was sixteen, he said, I could draw like Raphael and it took me the rest of my life to learn to draw like a child. It is true: he could draw with a depth and sensitivity and sureness of eye and hand to equal Raphael, and recognized that it was not enough. That it would never satisfy his need to make work that was his own. One of the most important artists of the twentieth century. The direct descendant of Cézanne. An artist that influenced all those who followed him. Who at the same time amassed a fortune through the sale of his work and used it to buy houses and studios all over France. There was always a beautiful place to live and work and a beautiful woman to spend time with or to act as an inspiration for the work itself. So what? What does it matter if I know any of this or not? His work can take your breath away, can excite your mind as well

as your eye, can lift you up off the ground and rattle the complacency or the sameness of your days. It is, as people used to say, a trip and a trip was nothing but a transcendent experience. Simply knowing Picasso and his work can provide that experience for you. Who does not want to be transported in this life, who does not want to be thrilled, who does not want to be removed temporarily from the difficulties and the stresses of living in the modern world?

There is work to do, though, to benefit from what exists, from what is available to everyone. The work involves study and the gaining of knowledge. The knowledge gained is the key, the mantra, that opens up the channels to experience. The Way of Art. A direction that will take whatever you want to bring to it.

The other side is practice. Where are you, where is your mind, what are you thinking about two hours into a drawing of a figure lying on a chaise at eye level before you? There is silence except for the sound, the dragging and the rubbing of charcoal or graphite in the room, and you look at your watch and think where has the time gone and I am not even close to finishing in a way that would be satisfying. Practice is the vehicle for the journey. The act of drawing will take you and make you push on through all the resistance of the culture toward art, and the negativity of the early years of your education, and all the doubt and lack of self-confidence—and it will let you step outside all of this and be lost for a while in pure process and creative expression.

9

With the birth of Modernism in the 1860s as a reaction against convention and Classicism, artists began questioning and breaking all the established rules. That seems to have become part of what it means to be an artist, or at least an artist who gains some recognition as an innovator, an influence to those that follow. So in immersing oneself in the Way of Art one is spending time with a number of artists who opposed the status quo and who rebelled against authority and challenged the rules of conventionality as far as they applied to the making of visual art. It is perhaps for this reason that artists are held in so little regard by the establishment of business and politics and why art is not thought to be a substantive pursuit in life. But what fun for you, the person seeking a way to ward off the calcification and the drudgery of the day-to-day. So many of these artists were brilliant about their work and did brilliant work that excited the eye and the senses and lit up the otherwise dark corners of being alive. Who better to spend time with? And the work endures forever, always there to consider and, more importantly, to reconsider as what one is drawn toward changes with time and age and experience. Modigliani is an example. His style, a touch simplified and perhaps primitive and seemingly within reach had great attraction to the young person coming to art for the first time. Modigliani was an artist who

was easy to love. But with more knowledge and awareness of art and of art history, and with age and the increasing complexity of being human, it was easy to turn one's back on Modigliani and see him as too simple and not one to endure the test of time. But today, twenty years later, there is great pleasure to be had in careful study of the work he did, and seeing the subtleness and the comprehensiveness of his technique and the expressive human quality that is conveyed from each of the subjects of his portraits. He was no Picasso and he lived for only a short time but the work touches the vein of humanity and is sensual and alive with character. His nudes are particularly wonderful and done with such a loving and sensual hand.

I must be back on the zeitgeist because flipping through *The New Yorker* online, looking for images of Cézanne as mentioned in the February 28th issue, I came across the March 7th 2011 issue and the review of a book on Modigliani:

March 7, 2011

In this week's issue of the magazine, Peter Schjeldahl writes about Amedeo Modigliani, the subject of a new biography, by Meryle Secrest. Modigliani, Schjeldahl writes, was "an illustriously self-destructive painter whose prestige, as I see it, rests more on his perennial appeal to sensitive adolescents than on grownup critical favor." Here Schjeldahl discusses that appeal, as well as Modigliani's bohemian life.

With regard to Cézanne's *The Card Players,* that was being shown at MoMA in 2011, Schjeldahl describes Cézanne's technique as "seemingly arbitrary rough brush strokes adding up to a man."

Cézanne knew what he wanted to paint but the goal, the idea, the subject, does not take the life out of the picture, does not make it rigid, does not rob the image of air and a kind of spontaneity. It is like modern writing, poetry, one word leading to another, word driven writing, with underlying themes, but the interest is in the getting there not in the articulation of the theme. The interest is in the making of the man, the painterly elements with which the man is built, the notion of how to build this man, this apple, this onion, this field, this mountain, this woman, this group of women bathers. Get rid of all the fluff and fat and extraneous distracting information and work the essence of what builds form. Brush strokes like bricks laid on the planes of the form. Solid, permanent, but unlike bricks, fluid and not stiff. The precursor to Cubism, to the brushwork of Cubism, to the massing of form and plane that was Cubism. There is relevance to the contemporary novel here, a cue to what I have been trying to do. Eliminate the obvious. Ignore convention. Build with strokes, words, that rub up against each other to make something greater.

Modernism is finished. The argument is over. We are in the postmodern period. Or beyond. But the challenges are still how to make something real without slavishly adhering to rules and conventions of the craft that are seen to be more important than

the content itself, that rob the work of its own life, that suck the air out of the creative room so that no spark is possible.

Schjeldahl: "Cézanne is not a performer, not a showman. Cézanne doesn't try to interest you, you must be interested and when you are you feel your intellect grow in leaps and bounds."

10

Here is a condensed version of seven hundred years of the history of Western art: from Giotto around 1300 to Raphael around 1500, from the Early Renaissance to the High Renaissance, from say Giotto's *The Lamentation of Christ* to Raphael's *School Of Athens,* the struggle of the artist was to render three-dimensional reality convincingly on a two-dimensional surface. It is all an illusion and things like perspective, which can be taught now in ten minutes, took about one hundred and eighty years to perfect and develop as something theoretical that could be easily passed from one artist to the next. In this time there were amazing artists and masterpieces created. Simone Martini, Massacio, van Eyck, Fra Angelico, Parmigianino, Mantegna, da Vinci, Michelangelo to name just a few. Once these skills were mastered, each artist could use them to articulate their vision and for the next three hundred and fifty years some phenomenal art was created.

Everything from Bosch to Titian, Caravaggio, Rubens, Rembrandt, Velázquez, Vermeer, Poussin, Claude Lorrain, David, Ingres, Goya, Turner, Delacroix. All amazing artists who left spectacular paintings. These works had so much depth and substance and were built on big themes for the most part. Think of music at the time, think of painting, and the complexity was similar. Then something happened in 1862 that marked the beginning of

Modernism, the Modernist dialectic, the argument with painting about painting itself. The arrival of photography on the scene had something to do with it but it is only a fraction of the story. These people were artists and artists don't like convention and the world of art, commercially, was changing as well. An artist's survival was no longer dependent on a patron whether it be the church or the nobility. In 1863 Manet painted *Olympia*, a nude who is reclining and staring out of the picture directly at the viewer. She is a prostitute and she has a maid and a cat and lovely satin sheets on her bed. What Manet did was remove any sentimentality from his painting, and most of his subsequent painting. He said to himself, I will let the viewer decide how he feels. I will not manipulate the viewer's feelings about this woman. No poor downtrodden exploited sex worker. The viewer will have to confront her and meet her gaze. From Manet to Cézanne there was a progression of reducing the expectations, reducing the idea of what a painting was. Monet, Gaugin and Cézanne were the great innovators but there were great practitioners like Degas and van Gogh as well. What happened is that with Cézanne, even the human form was reduced to its essential shapes. His fruits and his portraits and his bathers and his landscapes were all about reducing the existing reality to fundamental shapes. His work is powerful, and when you really look at it you feel you are in a room with an artist thinking unlike any artist ever thought before. He is not called the Father of Modern Art for nothing. What was now no longer in

a picture was any illusion of depth or perspective, and any attempt to disguise the fact that what you were regarding could not be anything but a painting. Flat picture space, no emotional content, no attempt at photographic representation. Then Matisse freed colour from its moorings of logic and Picasso threw out any of the previous rules and created Cubism which was a way of playing with the picture surface and having fun with the illusion of form. Following Matisse, Kandinsky in 1910 painted a picture that was purely abstract: an arrangement of shape and colour in a picture space. A composition, in other words, that was only about colour and form. All painting is such an arrangement, though some forms sometimes represent things others do not, nor in the Modernist tradition do they have to. Think of how music was changing. Think of Satie. Think of Elvis Presley. Think of jazz. Think of the controversy surrounding *Voice of Fire* by Barnett Newman, that the National Gallery in Ottawa bought for almost two million dollars in 1990. It was in this Modernist tradition. No one said you have to like it but it is important to know where it came from. With Cézanne and Picasso, artists stopped making work for the sole pleasure of the viewer. Modernism demanded that the viewer bring something to the table. When that is possible, the experience of art opens up enormously. One can take as great pleasure in beholding a room full of Rothkos as one can looking at a da Vinci. One's experience is different but the painting is the source of great pleasure and excitement and can stir the spirit and the soul.

The above is a brief history of Western art that I sent a friend one morning around 7:00 a.m. after a dinner party where the conversation turned toward art and as so often happens most people at the table were uncomfortable with notions of abstraction but more uncomfortable with the idea that collectors and museums pay vast amounts of money for works of pure abstraction. $30,000,000 for Pollack, a Rothko. $10,000,000 for a Barnett Newman. The amount of money and the object it is buying make little sense to the majority of people. This brief history was written simply to contextualize abstract art and to illustrate where it came from. In the history of Western art since the Early Renaissance there has been an inevitability of the emergence, the invention of pure abstraction. If history is a living force and if there is a momentum toward certain significant events then the art historical dialectic, the arguments that artists formulated with the medium of paint and the notions of what a painting could be meant that in time someone would say, fundamentally, that all paintings have colour, form and design, so why not eliminate the representational dimension and use those elements for what they are. There was a famous quote that said something like, "Before being a war horse or a field of flowers or a nude, a painting was an arrangement of colour and shape in the picture space." It was made by a twentieth century painter who came from a classical tradition and began exploring pure abstraction. Kandinsky was the first. In the history of art, cinema and literature, it is difficult to top a Russian with a great idea. Kandinsky had a great idea.

Painting, he thought, could work like music, and each mark he put on the canvas would be like a note or a sound in a musical composition. The marks would represent nothing but his notion of sound and he would pile them up on the canvas in a rhythmic, spontaneous and colourful way. His early abstractions are some of the most satisfying ever made. Satisfying in the way they please the eye and engage the mind and maybe touch the heart and the soul. In other words, they deliver a pure visual experience that is not reliant on the interpretation or representation of things we see in the world around us and the work is not first judged on the accuracy of that interpretation. It stands or falls on its own terms and the viewer has to meet the work on its own terms and not through a number of suppositions and preconceptions and not with the gage of accuracy as the cue for the initial response. The idea of the viewer having to meet the work on its own terms is the beginning of the problem for many people with abstraction. They have no knowledge, context, framework, or history, viewing or otherwise, to bring to the work, and all they see are gestures with paint that represent nothing and ultimately mean nothing. Where is the value in that?

Taking a path of learning about this art, of opening oneself to the experience of beholding this art, is a kind of liberation: personal, aesthetic, intellectual, visceral, in the same way the work itself was initially a liberation from all the conventions of painting that came before. Kandinsky broke all the established rules and created something beautiful, created a beautiful object.

Picasso on the other hand, though the creator of many beautiful objects and the breaker of many rules, never let go of representation, never painted a picture that was not based on something seen or imagined no matter how radically different his interpretation. In other words, he never just pushed paint around to see what would happen without something in his mind's eye that was connected to the life in and around him. The Russians kind of owned abstraction for a while with Malevich being the next practitioner and maker of beautiful, poetic, abstract images, so rigorous and disciplined and intellectually exciting in their execution. Then Schwitters (German) with his found object art and Miró (Spanish) and then the American Abstract Expressionists including Rothko (Russian). Tough, muscular, hard-living painters who grabbed a hold of two decades of artwork and made the significance of that time theirs alone and with that pulled the centre of the art world from Paris to New York where it remains.

Working with abstraction for the occasional or amateur painter can be a great deal of fun. But for the professional it is much more difficult to achieve something original after a hundred years of human gestures and ideas about non-representational art.

11

Churches, especially the old churches in Europe, the original Gothic cathedrals and the Romanesque churches and the churches that mixed up the styles and ones to which the architect brought something of his own, these churches were designed to knock you out, to shake you out of your visual complacency, to startle and overwhelm you and make you look up and make you feel like your spirit has been touched and it is rising. It is good to see one church a day when you are travelling and then stop after a few so you don't become fatigued and begin to just run in and out preventing the building from reaching you. It is good to be relaxed and curious and opened to some kind of experience. I remember the first time we entered the abbey at Vézelay, France, the one the Crusaders left from. It is a Gothic building, early and pure Gothic in construction and intent and after having been in Italy for a few summers it was striking to enter a church, a cathedral, where the walls were unpainted, where the walls were simply white and the pillars stone and where walls soared what seemed like a hundred feet to the arc of the Gothic arch. I was with my wife and two young sons. The boys were five and eight. I knew they were perceptive and thoughtful children and as we entered the building I put my hands on my eight-year-old's head and just gradually increased the pressure on the top of his head

until we had entered the main sanctuary, the nave, and in suggesting he look up I took my hands off his head and I could see the awe he experienced getting a feeling for the full force of the space and the intent of the design to make you feel closer to God and somewhat humbled by being so small in the vast height of the space. That he is about to graduate from architecture is probably not directly related to that experience of wonder and the sheer power a building can exert on an observer, a worshipper. But perhaps it made such an impression and unconsciously he was guided toward architecture so he could create a structure that would have a similar impact. It was for all of us a joyful experience and it was provided by a work of art. In life there can be many such experiences that come from seeking out the art or being comfortable with it when you stumble upon it as we did with that cathedral. Outside, we looked at the flying buttresses supporting the vault. They were stone but seemed a little flimsy, not quite up to the task. But what a concept really to expose the structure like that and keep the form and function clear.

Visiting the Arena Chapel, also known as the Scrovegni Chapel, in Padua, Italy, a half hour from Venice, was another exalted experience. The building is a simple early Romanesque rectangle, built around 1300. It is a small space comparatively but there is something perfect in the proportion and in the detail, like the metal rods that stretch across the top of the walls to hold the building together and keep the walls from falling over. The painting was done by Giotto and it was his first serious commission

and the forms of the figures in the Old Testament images that run above the New Testament images depicting the life of Christ are such solid forms that they echo the form of the building and there is a harmony between the images and the form that contains them. I am sure this was not intentional. It was just the coincidence of a great artist at the beginning of his exploration of human form getting to paint in a building that was early in the evolution of ecclesiastical design. There is perfect harmony, synergy between them. Giotto's design for the interior makes full use of the space and it is his design, his layout, his concept and his colours. The blue of the ceiling is magnificent, a shade of blue that can never be forgotten and it is the blue of the spirit and it reminds you of that dimension in yourself and perhaps that dimension has been neglected but in that space it comes rushing forward.

Giotto was the first artist to actually try to express emotion through the gestures of his figures and *The Lamentation of Christ* is one of the saddest pictures ever painted. As artistic skills were developed and perfected over the course of the Renaissance and into the Baroque, the capable artists could all depict grief or sorrow in the expressions on the faces of the characters in their paintings as well as in the physical posture and gestures of these characters. But there is a difference between depiction and expression and Giotto with his nascent technical skills, struggling to invent the language of representational painting, expressed grief in a most powerful way, creating an image that resonates with emo-

tion. In that picture, one of a number of panels on the wall of the Arena Chapel, Christ has been taken down from the cross and is lying dead on the ground, his head cradled tenderly in the hands of his mother Mary, his feet held by Mary Magdalene and around him some of his disciples and some elders from the community. All this on a stark and barren landscape with some of the mourners making broad gestures of grief, arms outstretched and bodies bent over or hands curled and faces tucked into the hands. Sadness pervades the scene but looking up from the body and the mourners into the blue sky there are a number of angels and the angels are distraught and their flying has been affected by their grief and their flight paths are on colliding courses and some seem to be falling out of the sky and others are crying, wringing their hands, and there is this wild, erratic energy in the sky embodied by the angels that reads in an abstract way like wild painterly gestures of raw emotion. This is where the true expression comes in and there is an added dimension to this in its contrast to the solid forms of the figures below who appear to be carved from stone and who could not be moved by the force of a hurricane.

It might be a good place to mention that viewing art takes time. A piece does not reveal itself immediately in all but the most superficial way. Watching people move through a museum, sometimes with the aid of an acoustic guide, they are moving quite quickly and in so doing miss a great deal. The idea is to stop and look, stop and observe, stop and contemplate, stop, and in a sense, visually meditate, examine and absorb what a piece might

be offering. Certainly that cuts down the number of rooms that can be covered in a museum during an initial visit and it cuts down on the number of pieces that can be viewed before fatigue sets in. This experience of looking and thinking and feeling and having the emotional rush that can come from it is tiring in the best sense of the word. It is also rewarding, exciting and invigorating. The person who stops and looks often presents an obstacle to the flow through a gallery but that should not be your concern. The work exists to be seen by the public.

Now let's say you knew nothing of Giotto and found yourself in the Arena Chapel on your way to Venice, and Padua—with its arcaded walkways and its monument by Donatello—was on your checklist of things to do in the region. You might enter the chapel and look around for a few minutes and be moved by the colour and fundamental nature of the painter's style and then head for the door, taken aback perhaps by the *Last Judgment* images of Hell over the door where you exit the chapel. But perhaps, if you'd read this brief passage here about Giotto and the expression of grief and something about the paintings and the building, you might think to stay and examine the work. And then an hour passes and you are still there enthralled and touched by the beauty all around.

That, then, is a different kind of experience, one you are not likely to forget and one that is more than a checkmark on your list or a few shots with your iPhone for the record. The suggestion that comes from this is if you are planning a trip and there is

art in the area, reading a little about the architecture or the artists or the accessibility of painting or sculpture and the subject matter or the theme of that work and the era when it was created, would add quality to your experience and bring surprise and depth to your journey.

12

I don't know anything about art but I know what I like.

13

Making it look easy is the hardest part. There is a painting by
Henri Matisse called *Large Reclining Nude* (or *The Pink Nude)* in
the collection of the Baltimore Museum of Art. The painting is
26 x 36 inches. In it a large female form reclines on a pattern of
blue and white tiles, an elbow running out of the top of the can-
vas, a hand and foot running out the bottom, and a foot and knee
out the far side. She is looking out at the viewer and is rendered
simply—in a Matissian way—with a dark outline and a more or
less solid pink body. There are a few other forms in the painting
that seem to represent things you would have in the bath like a
sponge and maybe a seashell-shaped soap dish on a red ceramic
shelf, and then a thin line of larger white tiles above that. The
painting is colourful and expressive in the form of the figure, and
infused with a feeling of *joie de vivre,* and it looks so easy and
effortless that anyone could paint it if they had a mind to do that.
There is evidence, though, that Matisse painted over twenty ver-
sions of this picture before he got it right, before he was satisfied
with the quality of the image. The versions all have the model in
a variety of postures and positions and with variation in the pro-
portions as well. It is possible to follow these variations and see
something of what Matisse was after in his work, and how impor-
tant it was for him to achieve a work that resonated with him.

It is why no artist has successfully been able to utilize Matisse's style and achieve a similar result. He was the master of pictorial design and the rigour of his design was disguised in the seeming simplicity of his execution.

14

Going to London after beginning to write this book seemed fortuitous. It gave me a jolt, a kick in the art-thought side of the head. Matisse played a part in that as well. His 9.5 x 9.5 feet purely abstract piece, *The Snail*, 1953, done with cut out shapes of paper, at the Tate Modern, was magnificent and a revelation about how he had come to think about abstraction as being the purest form of painting. But the piece itself was just so beautiful to look at, so fresh and like a distilled essence of Matisse's brilliance as a designer of images. In that, he had few rivals, Degas being one of the most formidable. We were in London for five days and most of each day was spent looking at art. The looking was so pleasurable and on so many levels of experience. There was the notion that I had seen some of these works many times in courses I took, in books I read, and had used them in courses I taught, in lectures I gave, in formulating my own ideas about the history of Western art. So seeing these pieces for the first time in the flesh was potent: they were no longer icons but living works, tangible and approachable and pinned down for observation and examination. Rembrandt's two self-portraits at the National Gallery for example: the one at age sixty-three that I use as an example of man able to look at himself and render what he sees without vanity, without a need to glorify himself in the way that

say, Velázquez does in *Las Meninas*. They were more or less contemporaries but had very different lives. Rembrandt had been the king of the hill for a while, but then fell out of favour. He lost his wife who supported him in many ways, then he met a younger woman and was revitalized, but humbled by his experience, saddened and wounded by life. All the thought and feeling, uncertainty and the intimations of mortality, and the struggle to live and make some sense out of it all is there in the painting of the sixty-three-year-old man. It is powerful and draws you toward it with feelings of empathy and compassion, and also a sense of awe that a man was able to paint this picture, to take paint, pigment, and with brushes move it around on the surface of a canvas and not stop until he had created the person you see hanging on the wall. Remarkable. And that is one aspect of the experience, the recognition of the skill these artists had and the skill they needed to achieve any kind of recognition in their time. They could all paint and they could paint everything they needed to paint. And when they were great, like Rembrandt, there was no hint of labour or process or struggle of any kind in the work. It was really obvious looking at the Frans Hals portraits beside the Rembrandts that Hals was just an illustrator in comparison, and things my professor used to say to that effect made total sense when I saw the actual work.

So for me, the long-time student and teacher of art history, with a life-long curiosity and interest in visual art, as well as a serious engagement in being a practitioner myself—working hard for

months at a time ruminating, on the history of art and the work of others, struggling with my own work to give it some spark of originality and some visual potency—looking at the work of the great masters is tempered by these experiences but nothing I knew could prepare me for the power of the work itself. To feel that power I had to be in a state of pure concentration and focus, and I realized there were subtleties in that as well, with a difference in the depth of experience in museums where I was allowed to take pictures compared with museums where photographing the works was not allowed. Taking a number of pictures put a little barrier between me and the experience of viewing the work. I was cataloguing what I was seeing and making a decision, in the moment, about whether to record seeing the piece or not. That was determined by the nature of the piece, by the fact that I might be able to use it for teaching sometime, by the surprise and quirkiness of it, by its place in the pantheon of art history, by my need to have a visual reminder of the moment of seeing it, of the day and the place, by my own delight in just looking at it. These thoughts were all there though not articulated or checked off consciously but the fact of them being there in the room during the looking at the work put that between the work and my experience of the work. Where no photographs were allowed, more time was spent with the great works like the Velázquez *Toilet of Venus* (*The Rokeby Venus*), 1647-51. Other than in pictures or books I had to think I might never see this painting again, and it is one I love for the sensuousness of the female form and the sub-

tle tonalities throughout, and the cleverness of the concept. I stood with it for ten minutes or so and thought perhaps I had to try to reproduce the work photographically as an homage. There is something quite contemporary about the shape of the woman's body that let me think I might be able to find a model to work with for a project like this.

Is it the act of seeing I want to analyze, break down, deconstruct, take a look at? Or is it the act of looking? Looking implies observation, consideration. Seeing implies recognition and understanding. The art experience is both, really. It is not about the language, though, but the effect of these actions on the mind and body of the viewer.

15

The old expression about the eyes being a window to the soul was meant as an aesthetic consideration: looking into someone's eyes, you could see the truth of who they were, but here I am thinking that perhaps it is the eyes that open to the soul, the eye as the conduit for the external world to the soul. In this way, when you look at something and are touched by what you see, it is through the eye that this vulnerability, this sensitivity is exposed. Everything can be felt through seeing. One day I am in the National Gallery in London looking at a van Dyck portrait of a man and thinking how effortlessly the work was painted, and how there is no obstacle of technique between the viewer and the experience of the painting, which gives you a thoughtful man with moist eyes aware of the passing of time and what might be left to him. He is a handsome, thoughtful man, and it is as if the life of this person flowed off the end of the artist's brush without restraint or self-consciousness or doubt. I marvelled at the work.

The next day there was a portrait of a man on the front page of the newspaper and he was crouching and crying and twisted in pain and it was snowing and he was looking at the ruins of his house in Japan that was destroyed by a tsunami of awesome proportion and he was so tragic and seeing the image made me want to cry. He was only one of hundreds of thousands of people

uprooted by the unleashing of nature's force, and the ever-ticking time bomb of the nuclear reactors in the area spewing radiation into the air and threatening to blow and release radiation into the atmosphere to travel all across the earth. There was a deep feeling of empathy looking at the man, and then there was fear of the unknown and some selfish concern about what may happen here, so far away, at the moment, from the horrendous events in Japan. All this reaching the heart and the brain through the eye.

There is a painting we stumble upon in the National Gallery by Giovanni Bellini called *Doge Leonardo Loredan*. It is a stunningly lifelike portrayal of a man dressed in an exotic silk brocade jacket with a high neck. His posture is absolutely erect and his gaze is off to one side, avoiding the viewer. He wears a hat of the same fabric as the jacket that has a wide band of another fabric circling his head, and the hat rises into a point at the back looking almost as if a duck were resting on his head and we were seeing it from the back. Under the hat his head is bound in a white fabric that covers his ears and has two threads dropping to his shoulders under each ear that look as if they could be used to tie the headpiece under his chin should there be a strong wind. He looks to be between forty-five and sixty and has a thin, well-chiselled face with a strong nose and mouth set in an expression of confidence but neither smiling nor frowning. Bellini was a master colourist and in this painting he uses a stunning shade of blue for the background, a flat blue not meant to imply the sky or anything other than maybe a wall in a room, but even that might be

a stretch. To me, it is Bellini choosing the blue because of its colour and the way it helps to bring the painting to life. One is immediately moved by the skill of the artist in creating this image, and capturing the specific nature of the Doge, the leader of Venice. A serious man with great responsibility. I had seen the painting in reproduction, in an outstanding reproduction of the highest quality and framed in a subtle wood frame with a grey tint to the wood. The reproduction hung in a hallway at the school where I taught for a number of years and once, when they were cleaning and painting the walls and the reproduction was taken down, I picked it up and took it to the art studio and hung it there. I had put up a few pictures, another sketch in conté by Bellini, a self-portrait, and a study for one of the children in *The Virgin of the Rocks* by da Vinci. These pieces were at the pinnacle of draftsmanship and the ability to represent the subject, and they stood as an unspoken challenge to the students working in the studio to always strive to do their best work. Seeing the painting made me think about the years I spent working in the school, the years I spent teaching in the art studio, the students I had taught and where some of them are now. One was in London having just finished a Masters of Fine Art at Central St. Martins; we were scheduled to have dinner together the next evening. She is now a friend and a fine artist. Over the course of my career there had been the joy of teaching and of seeing the work the students were producing and the way in which they were comfortable and in touch with their real selves in the studio. A number had gone on

to careers in art or architecture, design, photography, fashion, film, curatorial practice, or academia as art historians. When I taught I tried never to think of the implication of what I was doing, of the way I was working, and the impact it was having on a student's life and the direction that life might take in the future. The atmosphere in the studio was my creation and my gift to the students, allowing them to develop their abilities without fear of being attacked or belittled. Now that I no longer teach young people I have begun to take some pleasure in thinking about what I accomplished, the direction taken by so many of my students in their lives and careers, and how art is at the core of so much of what they do. It was a revolution of the personal—the personal is political, as they say. It was focusing on the individual and having the art-aware and art-positive individual go out into society as an art-citizen, and become a force in their own right for the place of art in the broader culture, for bringing art to the forefront and having it recognized as essential in a culture that for so long has relegated art to the periphery. If I kept going with this train of thought and opened it up further, my entire life could be articulated, peeling away the layers like an onion until I reached the core. This all from seeing the Bellini at the National Gallery on a Thursday in March.

The eyes are the entry point, a threshold beyond which is the mind and the heart and the soul. For this reason, it is essential to learn to see, to work the muscle of vision, to force oneself to look and question and analyze.

16

The artist's way of life held an attraction for me when I was young. Artists were like Beatniks with a purpose. The Beats, how quaint and dated that sounds now in these days of digital discourse and the character constraints of Twitter. Imagine Alan Ginsberg tweeting *Howl*. The Beats were outsiders, they represented an alternative to the way of life proscribed by my family and the schools and the culture where I was raised. The Beats were poets and writers and painters and actors and maybe small-press publishers or owners of bookshops or cafés. They travelled the world and were not tied down to jobs with pensions, and experimented with drugs and explored different religious practices and placed no restrictions on their sexual orientation. The Beats were the Bohemians of my youth and I was drawn to places like San Francisco, New York's Greenwich Village and Paris where these cultures flourished. They were iconic for me as were the books and periodicals, and the soundtrack of jazz and folk music, of blues and R&B and early rock and roll. There was so much to read and listen to, and so much to do and little of it had to do with achieving in school and with planning or preparing for the future. The future was enormously uncertain as we had been diving under our desks and having nuclear air raid practices, and people were building and equipping bomb shelters in their back-

yards. The idea of a future dimmed or diminished for many of us, thinking that if the war came we would all be dead. It was a liberating thought that I think led the full-blown marijuana, hashish and LSD-driven sixties, the tune-in turn-on drop-out sixties, the back-to-nature-living-on-a commune sixties, the migration-to-the-West-Coast sixties, the great music and hedonistic gatherings of thousands of people at a time. All of this driven by thinking the future was uncertain. Live in the moment—be here now—became a mantra, as did the personal is political. People took risks and stood up for their beliefs. The civil rights movement, women's liberation, gay rights, all changed society affording more choices and broadening opportunities. An easing of censorship created more room for expression in the visual and written arts. Everyone was getting older though, and some were having families. and the fundamental reality was that it was necessary to earn a living to occupy a place in society and be able to provide shelter and comfort for yourself and your children. Materialism never lost its hold as the fundamental value of this culture and consumerism, its twin, never stopped being the driving force behind the economy that made the Western democratic way of life possible. Nothing has changed. The economy has been floundering since 2008 and public services everywhere are under assault from lack of funds. And while I write this today, nuclear reactors in Japan are burning, entire towns in that country have been wiped out by earthquakes and a tsunami, there are revolutions in many Middle Eastern countries, and NATO is

bombing Libya to protect the rebels there from being massacred by a leader who does not want to cede power in the face of a popular uprising. And we are here thinking about the transformative powers of art.

People who chose to make art, who chose to be artists, are making a choice for process over comfort, are still stepping outside of the prescribed societal norms and risking failure by opting to follow their creative instincts. There is much trade in the arts now as a commodity, and with that there are chances for great wealth and success that were unimaginable for artists even fifty years ago. One can make a living if one's work catches the attention of the collectors and curators and other buyers of art, as those with wealth are competing to own a limited number of pieces. Still there is no guarantee, nor has there ever been, for the artist or the writer or the musician of even making a living as there is for the doctor or the lawyer or the teacher or the nurse. So the artist has to have the courage to step out. Or does the nature of being a creative individual automatically make that person an outsider for taking a stance that questions and challenges accepted notions and the status quo? Can you make art that is striking and original and well crafted, disciplined and rigorous, without a critical point of view on what has come before and on what currently exists?

At the age of twenty-one, certain that I wanted to become a poet, I went to Europe on a solitary journey—not self-consciously in search of myself or of experience, but as way to put

myself in the moment and remove myself from the cultural context in which I had been raised, and against which I had been fighting for three years. With a little money, inherited from my paternal grandfather, I flew to London and bought a motorcycle and crossed the channel by boat arriving in Oostende, Belgium (since France was closed because of the May 1968 upheaval by students protesting in Paris, who were joined by the entire French labour movement—effectively shutting the country down for a few days).

I had no agenda for my journey, no plans, no prescribed destination, but there was a family friend in Vence, near Nice, and it was on my mind to stop there and say hello. The idea of going to Vence then influenced the route I took, heading south through Europe. From Geneva I followed what was called the Route Napoleon through the mountains to the South of France. I should mention that while I was in Geneva because the French borders were closed because of the student revolution, Robert Kennedy was killed in Los Angeles and with his death the last politician I had any respect for was gone. Martin Luther King had been killed earlier in the spring and then Robert Kennedy. I was devastated by Kennedy's death and sat in a chair for a day, hardly able to move. It was unusual for me to invest hope for the future in the words of a politician but Kennedy had elicited my trust, more so than his brother John, and when he was shot it seemed like there was no possibility of change or social upheaval in America, no shift in values, no respect for differences inherent in people. The

bigots and the racists and the defenders of the status quo contin-
ued to assert themselves on the culture and continued to win. It
was a suffocating intellectual environment for someone like
myself, and where went America at that time, Canada would
surely follow. In terms of narrow-mindedness, and repression of
arts and ideas, though, Canada was well ahead of America. I man-
aged to get focused and get up and get out of Geneva after mak-
ing a few dumb jokes about various conventions and striking out
with a gorgeous American woman who was working there for the
summer. The ride south was spectacular, one of the most dramat-
ic and physically beautiful routes I have ever travelled, and in my
ignorance I didn't quite comprehend the distance I had set out to
cover in a day. It was over five hundred miles of climbing moun-
tains and descending switchback turns and racing through valleys
only to come to more mountains. The mountains never ended
until I reached the sea. I didn't know that going in and each time
another mountain rose before me after thinking I was in the clear
my heart sank as was the light of day sinking and I was in the
middle of nowhere between towns like Gap and Sisteron. Around
7:00 p.m., I reached Vence and riding down the road to the cen-
tral square I saw the daughter of my family doctor who had asked
me to visit her and say hello. She had left Toronto to live with her
mother in France and was about seventeen at the time finishing
her high-school education. It was pure coincidence to see her like
that on the road and we talked and she told me her mother was
away and she was staying with friends and why didn't I return

and stay with them when her mother was back in town. That sounded like a good idea and we said goodbye and I continued on my way to Nice. During the next few weeks I was in Rome, Florence, Pisa, Genoa. In Rome and Florence I saw art and architecture I did not really understand, but was able to appreciate some of it nonetheless. I was more interested in being out on the streets and looking at people than being in churches and museums. One piece I had to see, though, was Michelangelo's *Moses*. There had been a framed photograph of the *Moses* in our cottage as long as I had been going there. It was a gift to my uncle from a friend of his when my uncle graduated from high school. My uncle, who left Toronto and ended up in Paris where he studied medicine and then psychoanalysis, landing eventually in New York to practice as a psychoanalyst, along with his wife, my aunt who he married in France, were the only people in my family with whom I felt comfortable and who seemed to understand and be sympathetic to the vague path I had laid out for myself in life. I spent a great deal of time with them through my teenage years, talking and absorbing their cultured way of life. They were intellectuals and sensitive and caring people. For that reason I had to track down the *Moses* and to see it was a revelation. Carved flawlessly from one piece of stone. How could someone do that? How could someone even conceive of that? I didn't know anything about art but I knew what I liked. In time I rode back to Vence and Gloria had returned to the villa she shared with her boyfriend Eddie, and Nonni, the daughter I had seen on the road.

Gloria was a dynamic, beautiful, red-headed woman. She was the first of my parent's friends to just get up and walk out of the comfortable bourgeois life she was living with her husband, a doctor, and her three kids, in Forest Hill Village, an affluent, tree-lined neighbourhood in the middle of Toronto. She had been acting in theatre and on TV and wanted to train and pursue a career as an opera singer. Where better to study than Rome. One day she just left her family and her possessions and the city where she was born and headed to Rome. It had been five years since I'd seen her, and when I arrived at the villa she welcomed me warmly and invited me to stay. Eddie was an artist, of Irish-Brazilian descent. The villa was not large but it had a beautiful garden and Eddie had created a studio in the garage by removing some of the clay roof tiles and replacing them with glass. I felt at home with them and was reminded of how I felt with my aunt and uncle in New York. Gloria knew everyone and everyone knew her and through her I got to know some of the artists who were working in the region at that time. It was my first exposure to artists as people and I had dinner and drinks and talks with many of them during the ten days I was there. Everyone had a working schedule, a regime, as they called it, that was roughly like this: wake early, have breakfast and work until around 11:30, then head to the Café Régence for a before-lunch aperitif and talk with friends, then lunch at home and a siesta and then work until 5:00, and return to the café for drinks and talk with friends before having dinner with some friends and, most likely, after dinner return to

the café to socialize further. It seemed like a perfect way of life and I got into a routine of writing for part of the day when I wasn't out exploring the region on my motorcycle. Gloria and Eddie introduced me as a poet from Canada and that's what I was and there were times during the stay when I read new work aloud to people at the café. It was the first time in my life that I felt at home and alive and I wanted that to be my life forever. The people I met were from France, Canada, Poland, Australia, Belgium, Britain, Ireland, Sweden, Hungary, and in this galaxy they were all forces, individual planets, spinning around the arts. The arts were the centre of the world there in southern France and there were some beautiful galleries and museums and artists like Man Ray, Chagall, Picasso, living in the region. I was very happy working as poet. It had been a few years since I started writing and I had edited a literary magazine at U of T and had published some pieces and so felt legitimate and in my milieu. There was nothing else I wanted but there was the question of money and it was running out and I had to live and poetry at that time was not going to suddenly support me, so I headed back to London to sell the motorcycle and wait for my girlfriend from Toronto with whom I had planned to meet up in early August.

In London I lived in a small room in Hampstead. The room was about seven feet wide by ten feet long and was on the top floor of an old residential hotel. The bathroom was down the hall and the wall separating me and my neighbour was paper thin and she had a boyfriend, an older man, who visited frequently to

watch TV and have sex and there was not a sound that emanated from that room that I didn't hear. I had a friend with a typewriter who lived a few blocks away and during the day I would go to her place and write, using the typewriter while she was at work. We became good friends. London was not the South of France.

When my girlfriend arrived we did return to Vence and she loved the region as much as I, and we stayed with a sculptor I had befriended through Gloria. The region was physically beautiful and the nuances of that beauty, the arid soil, the shape of the trees and the plants, the rolling hills, the rocks and the sky as well as the nature of the architecture, the stucco houses with tile roofs, and the age of the buildings in the towns, were all appealing and made it seem like the most beautiful place in the world. It was essential too that if you were going to be an artist you should be in a beautiful place. Not having a great deal of money was inconsequential in a place of such beauty. What was missing from life that money could buy?

In time I finished school and worked as labourer building swimming pools, and my girlfriend, who I married, worked as an editor, and we saved some money and moved to France and were able to stretch the time out from one year to two and our son was born in Cagnes-sur-Mer around the corner from the house where Renoir once lived. I worked with a sculptor on a large project for a few months and learned a great deal from him about process and patience and thinking in the long term, also about creativity

and about living life as a full participant. When the project ended we were living in Tourrettes-sur-Loup, a small village about six kilometres from Vence, in a building that had once been a donkey barn and was renovated into a two-storey, two-and-a-half room house on the rampart of the village overlooking the descending hills of the Alpes Maritimes with a clear view all the way to the Mediterranean Sea. I wrote a novel and a collection of poetry and lived the bohemian life I had sought. Then the money ran out and there was no way to make money in France and we had to return to Toronto. After working as a pool builder again for a season I took a part-time job teaching art at a private school in the neighbourhood.

Being with artists and writing had given me the ability to articulate processes and techniques that were often complex. While teaching in the studio I began to try things that I had avoided for years and slowly developed a vision for what I wanted to make and the practice I would develop as a visual artist.

Why this story? Had I formulated a mental image of the way I wanted to live, one that was contrary to the way I was brought up? In some way I think this was true and finding myself in France brought a kind of harmony to what I had imagined my life to be and what it had become. Moving back to Canada then and taking a job as a teacher in an old established independent school put me back in a more conventional way of life, especially since I was a parent and responsible for earning a living and

taking care of my family. I could handle that and did for many years but the fit was never comfortable, the role in the institution was not a harmonious one, though I never short-changed my students and continually pushed to expand the program and the options available to them in studying the visual arts. Having been a terrible student I instinctively understood the challenges to keep people engaged in difficult processes and to help them develop confidence and skill. It was the reality of what I was doing that didn't fit with the mental image I'd always had of what I had done but could no longer sustain for economic reasons. Ah, money! Does the need for it ever go away? Returning to *The Way of Zen*, yes—in the monastery with the complete surrender of all things material.

No matter how difficult the job became, how irritating the fit with the institution, how taxing sometime the perpetual pressure of working and earning, there was always art and the pleasure to be had in the immersion in the world of visual art. I had no personal agenda, other than ensuring my students worked to the fullness of their individual ability, and was able to take great pleasure in the work they sometimes produced. The days were spent talking to people and helping them solve creative problems and deal with the results of their efforts, the successes as well as the failures. I was making art as well and teaching the history of Western art and revisiting that story many times and seeing that it was evolving and not a one-track arc permanently etched in stone and determined by the words and thoughts of a

few thinkers who had authored all the standard texts. Challenging those notions through exposure and experience opened up the subject and made it a continuous source of excitement.

Looking at the work of artists over time, over years and decades, made it possible to see to the heart of what they were doing which was so different than the superficial touch each received when I was beginning to study.

17

If I had to pick ten favourite musicians whose music I come back to again and again I could do it. Bob Dylan, Bob Marley, Van Morrison, Neil Young, The Band, Fleetwood Mac, Jolie Holland, The National, Leonard Cohen, Karen Dalton. There is R&B, soul, motown, jazz and a great deal of rock and roll. There are many new artists as well who I come across and enjoy and sometimes buy a CD or two: The Decemberists, My Morning Jacket, The Lone Bellow, Weather Station, Alabama Shakes and others. When I think about art it covers so many centuries and the artists I like and their works are spread across all of them. Maybe a list of paintings I love and keep revisiting is more to the point although the artists created the work. Giotto, Fra Angelico, van Eyck, van der Weyden, Mantegna, da Vinci, Bellini, Bosch, Titian, Bruegel. Okay that's ten and it isn't even the seventeenth century yet. Editing tightly is difficult. How to think about it? There is only room in the life raft for a few paintings and the rest have to go overboard. Let's try that.

Maybe thinking about the raft of life is less of a cliché. Are we kept afloat by the flimsiest of structures throughout our lifetime? It seems like that sometimes, and at any moment the vessel can have its bottom torn open by a rock or stump lurking just below the surface. Illness. Accident. Being in the wrong place at the

wrong time. Natural disaster. Nuclear disaster. War. Revolution. All of these are happening right now all over the world and I am thinking about art. Why? Because it gives me pleasure and can be a distraction from the tension and anxiety brought on by the ways of the world. And through all the hazards, art seems to be all that endures in a concrete, tangible form. We have art going back to the first time humans were capable of making marks on a cave wall. This work offers us some understanding of who we are and from whence we came. But it does more than that. It is drawing and it is lovely, powerful drawing that was created mysteriously by humans who subsisted solely on what they hunted. We do not even know if they could speak or communicate with one another or if they were organized into jobs based on skills and strengths they might have possessed, but we do know they could draw and render with accuracy and sensitivity the creatures that surrounded them. How great is it to be able to visit a cave like Pech Merle or Lascaux and see this work firsthand? In the way the works appear in sequence on the walls of the caves and the way we now are led through the caves to see the works they are like the first art galleries. Put on your best pony skin vest and come to the opening of the Mammoth show. Drinks on the house. Dancing until dawn. Perhaps these people were the first artists, the first bohemians, and the motivation for the work was not to capture a likeness of the creature to be hunted the next day but to just capture a likeness and get it up on the wall and have a party celebrating the achievement. Or

perhaps putting the likeness of the animal up on the wall brought the animal to the party in a less rambunctious way. We don't know. All we know is the work and the work is 20,000 years old and still looks great, having been well-preserved out of the light and deep below the ground.

Life can be lived as a series of distractions from the inevitability of death which sets in the minute we are born, or it can be lived with more of a purpose, suspending disbelief about the inevitability of death, and assigning meaning to the achievement of goals and pursuits. Dropping your guard and turning off your cell phone and standing alone and considering the vastness of the universe and the randomness of all things both good and bad can be a frightening experience. Is it better to block that vision with drugs, alcohol, TV, electronic games, sports, gambling, death-defying challenges like climbing a rock face, and all the other things people do for distraction? Distraction from what? And what about the millions of people with no means of distraction whose day is spent walking five miles to get a jug of water and then walking five miles back, that is if they are lucky enough that day or week or month to have water available? So here we are, the more fortunate, on our raft floating along through life, afraid but participating and becoming teachers and scientists and engineers and nurses and bankers and builders and cleaners and drivers and lumberjacks and miners and having families and raising children to do the same when it is their turn down the road.

Van der Weyden's *Deposition of Christ*. Fra Angelico's *Annunciation*.

Da Vinci's *Virgin of the Rocks*, Louvre version. Rembrandt's *Self Portrait at the Age of 63*.

David's *Mme Récamier*. Géricault's *Derby at Epsom*.

Degas' *The Bellelli Family*. Picasso's *Les Desmoiselles d'Avignon*, Schwitters' *Blue Bird* and Howard Hodgkin's *Counting the Days*.

That's ten and totally unsatisfying and incomplete with many gaps in the idea of things I treasure. You walk along in art, through the rooms, down the halls, and most often you don't know what you are going to find. A show called "Picasso and His Influence on American Art" reveals a couple of Jasper Johns paintings you never knew existed. Every major artist's body of work created throughout a lifetime of artistic practice is so deep and dense that you can't know it unless that one artist was the subject of a doctoral thesis you had written or *catalogue raisonné* you were compiling. In London at the Tate Modern, there is a Clyfford Still painting, predominantly blue, that waits in ambush on a wall and is so stunning it takes your breath away. Or there is a late Monet at the National Gallery, sunset on a pond, that is so unexpected, surprising and moving. I mean there are a thousand works like this beyond everything you could know. But that is one reason why it pays off to pay attention. Where else can so much pleasure be had for free?

18

This morning I saw a series of books put out years ago by the Metropolitan Museum of Art in New York. I have seen the series before but it has been a long time. I was visiting my father and looking at the bookshelves in his den. Since having cataract treatment last year, I am now able to read titles of books and CDs without my glasses, and because of that I am noticing things that for many years I paid no attention to. These books were collected by my father's wife, who had a vague interest in art and culture. He has offered the books to me but I won't take them because they were hers, and she was someone with whom I didn't get along. Years ago she had purchased a drawing by Ken Danby of Pierre Trudeau. It was a rigorous detailed study that was used as a cover for *Time* magazine. I loved the drawing and my father offered it to me but I refused it, and instead encouraged him to donate it to the Art Gallery of Ontario in memory of his wife. This morning, I stopped by my father's house during my Tuesday morning walk. I am going to San Francisco on Thursday and my father is going to his step-granddaughter's wedding in New Jersey. It has been a while since we've seen each other and I wanted to touch base before our journeys. His caregiver let me into the house and he was on the phone, with Regis and Kathy Lee on TV, and I tapped him on the shoulder. He looked up at

me and I knew he had no idea who I was. It was a frightening moment and perhaps the beginning of many more to come. He looked and was without words and then he said, "Leslie," the name of my younger sister's ex-husband. When I spoke I think it came to him who I was and he said he was starting to lose his mind. This did not bode well for his five-day trip down to New Jersey with his caregiver. His skin had the grey pallor of the unwell, and when I said he didn't look well he said the woman who cut his hair yesterday thought he looked great. We talked for a while and I looked closely at the photographs in the room and the books when he left for a moment. There were many wedding photos from his extended family and ours, and pictures of my son's bar mitzvah twenty-seven years ago. One of the books in the Met series was called *What Is Painting?*

That is a question I have thought about often, but not philosophically for many years. I almost took the book down from the shelf and brought it home but resisted. What is painting? What does it mean to you? Is it a question worth considering? Is there an answer?

I want the answer to have weight, depth of meaning, clarity of thought, truth of expression, seriousness of intent. I want it to be a considered response. Something that perhaps a French intellectual would utter over cigarettes and coffee at a Parisian café. There are days when I feel this book is just skimming the surface, that the words are pouring out of the tips of my fingers and are not examined and rolled around in the light to ensure they touch

on the essence of the subject. After years of writing I know that it is more important to get the first draft down in any form at all than it is to tighten and polish as you go along eventually squeezing the life out of what is being written to the extent that it becomes impossible to proceed and the project dies on the page. Sometimes the initial thought is the most developed or the surest or the one with the most truth. This is often the case with my photography, a subject we haven't touched on at all. Pointing the camera at a subject and shooting three or four shots of the subjec,t the first and least considered is often the strongest. That is the one driven by instinct and intuition, by spontaneity and chance, the forces that let a work breathe. My thinking about the photographic image has changed a great deal in the last while. There is always the cleverness of a considered and worked image that might be impressive but the cleverness also gets in the way of delighting in the image. One is aware of responding to the cleverness of the maker rather than the brilliance or the beauty of the image. The cleverness is a barrier to the image taking a hold of the viewer and moving the viewer with its content and composition and tonality, the elements that give photographs their power. One can always applaud cleverness but one can never love it. Perhaps cleverness is what the artist falls back on when tired or burned out but still has to deliver and produce work. Somehow this is more obvious in photography than in painting. In Brassaï's *Statue of Marshal Ney in the Fog, 1932,* the statue is in the foreground in silhouette against a foggy night sky with a vague light like the

moon trying to burst through the fog and the word HOTEL clearly present in the upper right-hand side of the image attached to nothing, floating freely in the fog. It is a brilliant image but depressing as well in the obviousness of the conceit and the workings of the photographer's mind.

One doesn't want to applaud the thinking behind the art. One wants to be swept up by the force of it, carried away and down the seamless stream of its creation. With Robert Frank's series, *The Americans*, there is a photographer's mind in every image. You could call it the photographer's wit. The wit doesn't step forward and block out the image. The wit is a bonding agent that holds the elements of the image together and gives the image a dimension that makes the series deserve our attention. With painting the work is always visible and the work is what is appreciated especially when it is figurative or representational, whether it is Rembrandt or Manet or Picasso or Lucien Freud. We are seduced by the brilliance of the painter's technique, by his skill in translating three-dimensional experience to a two-dimensional surface and giving it some three-dimensional veracity. We want to touch the paint and the brushwork and see how the image is built and we don't balk. It is only when the painter lacks the skill or the finesse in creating the desired illusion that we become greatly disappointed. It doesn't happen too often with the masters but they can have bad days as well. There are some terrible Raphael portraits in the National Gallery in London. The goal then is the feel of ease, the feel that the artist just happened upon this subject and

opened up the paint box and the image flowed off the end of the brush like water flows out of a tap. We see the work but the work is not what we see. The labour, the painting, the brushwork, is integral and cannot be separated from the expression. There was a time when artists strove for a seamless surface and applied the paint in layers, glazes, one upon the other, and the surface took on depth and weight that way but there was no obvious brushstroke. It was the advent of photography that led some painters away from this classical technique toward a more painterly surface with an individual or signature style that had been obviously painted and could not be mistaken for a photographic surface. The painters wanted to say that they were making something that might be based on an observation but it was made by an individual with a vision, not by a machine with a light sensitive material that recorded the considered subject, by capturing the light reflected off the surface of that subject. Chemistry then brought the image into being and to the viewer it looked startlingly real. Paintings on a more visceral level feel real rather than look real even if there is a representational subject rendered with skill. A great painting is more than capturing the subject.

19

A few days ago I returned from a trip to San Francisco. I have family there and had gone to visit them. It had been two years since I was last in the city. It is a beautiful city, one of the most human in terms of scale and detail and also what it has to offer naturally like the Pacific coastline and Golden Gate Park and the hills and mountains all around it. There are residential streets with gorgeous houses crammed quite close together with views of the ocean and Presidio Park. The houses would cost a fortune to buy and I am sure cost a fortune to maintain. These streets, like Washington and Jackson, are a joy to walk and when I was there, in the spring, flowering trees and plants were in bloom everywhere. San Francisco also has a wonderful modern art museum, SFMOMA, as well as the de Young with its classical collection. I always try to visit SFMOMA when I am in San Francisco. The building itself is striking both outside and in, and its five floors of exhibition space are manageable and not overwhelming and can be seen in four or five hours. It was Monday and I had no other plans.

Starting on the fifth floor, the new sculpture garden was opened and there were many wonders to behold including two Calder pieces, both large and outdoors. One was a stabile in black and one was a colourful piece with a solid base and mobile top

not unlike a piece I saw at Yale University. There is a larger version of the stabile in a town centre in Italy and it spans an intersection allowing traffic to drive under or through it. There was also an Ellsworth Kelly sculpture that was essentially a flat slab of rusted steel with rounded corners standing in a base and parallel to the wall surrounding the garden. It was a minimalist piece and quite in sync with his paintings and surprisingly striking. Many other interesting sculptures were there as well, including a group of figures in bronze standing below a ONE WAY road sign. It was all exciting and I took pictures and felt happy and glad to be alive. The sun was shining and there was warmth captured and held by the walls of the garden. For me, coming to California from Toronto, having left on a day when it was snowing, the warmth alone was enveloping and soothing and only added to the appreciation of the art work. The sculpture garden was like a total environment that incorporated art, the elements, and vistas of the city, and couldn't have been planned any better. There were a number of shows I wanted to see that day and so I headed down to the fourth floor to an exhibition of photographs called *Exposed: Voyeurism, Surveillance, and the Camera Since 1870.* The title itself was seductive and being a photographer it was a show I had to see. This theme lent itself to a wide range of images and one of the first pieces I saw was a large, 24" x 30" version of a photograph Richard Avedon took of Andy Warhol's chest after he had been shot a number of times by a disgruntled member of his Factory crew. The scarring was brutal. I turned to the more

immediate work and started walking along the wall of the room, looking at the small vintage images from newspapers around the world.

Walking around an exhibition, one is generally focused on what is presented and one moves in sequence and some of the work is good, some of it is brilliant, breathtaking and exciting and then every once in a while a piece of art can just stop you in your tracks, frozen and disturbed by what you are seeing. This always comes as a surprise and it happened to me. Two images side by side by a photographer named Marcello Geppetti, called *Fire at the Ambassador Hotel,* 1959, caught me and wouldn't let go. The images depict a woman falling through the air, in her nightgown, against the stark stone wall of the building. She had jumped rather than burn to death in the hotel fire. We can't see if there is anyone on the ground waiting to catch her in a net and with the recent images of people falling from the Twin Towers during the destruction of 9/11, we assume she is falling to her death. In one picture she is covered by her dressing gown and in the other it has risen above her waist and her thighs and her black triangle of pubic hair are exposed. Not only does she suffer the indignity of being captured in her last desperate act before death but there is no grace in her posture, just a sense of panic and vulnerability heightened by the nakedness held in time for eternity.

The images have a nightmare quality–the desperation and the finality of the decision to jump and the fall through the air semi-naked and the falling itself–that is uncontrollable and random in

the positioning of the body. One can only feel heartbroken for this woman alone at night against the stark concrete walls and windows with either the blinds drawn or wide open to the night. Who was this woman? What was she doing moments before? Was she alone in her room or with a husband or lover? Did she have children? Was this her first time in the city? What made her choose the Ambassador Hotel?

Recently at the Tate Modern we stopped to watch a movie by an artist, Eduardo Paolozzi, that was a collage of images of urban life showing how with a good eye an artist can find pattern and composition in the structures with which he is surrounded on a daily basis. There was a soundtrack with this movie and after a while it was becoming grating and we thought about leaving but were enjoying the imagery and the sound was getting louder and louder and then there was a security guard rousing us to exit the building as the sound was a fire alarm and we were on the fifth floor and had to move quickly to the exit and the stairs and descend to the ground and people were doddering and talking, and again I recalled the images of the Twin Towers on fire and the stories of people racing down the stairwells filling with smoke, and encouraged my wife and son to move quickly and get out of the building. There had been bomb threats all over London and we never knew if this was a drill or was real but were allowed to return to the exhibits twenty minutes later.

I finally moved on from *Fire at the Ambassador Hotel* only to see images that had haunted my youth like *Immolation of a*

Buddhist Monk by Malcolm Browne, 1963, depicting a man, a monk on fire, sitting stoically on the road. The gesture was a call for help to the world and recently an Tunisian peddler set himself on fire after being charged a license fee he could not afford to sell his vegetables and the act sparked a revolution that toppled the government. There was the famous shot of the Vietnamese policeman shooting a man in the head at close range, taken by Eddie Adams, just as the bullet was entering the man's head and showing the distortion of pain, and then the other famous Vietnam War image, shot by Nick Ut, 1972, of the little girl running down the road naked after her clothes were burnt off her body by napalm. She survived and eventually settled in Toronto. From that room to the next where the shots were candids taken by famous photographers on the streets of cities all over the world, showing people captured unawares going about their business: walking, eating, kissing, playing chess. These images had their own power and the potency of the first room would diminish as I moved through the others.

Looking at hundreds of photographs is intense and tiring and after that I went to have some lunch before returning to the paintings in the permanent collection. One of those, Matisse's *Woman with a Hat*, 1905, is a Fauvist painting in which the woman has a great deal of green in the shadows on her face. It is a painting I used often when I lectured on modern art while teaching art history. What Matisse did with colour in this painting, using it for its own sake and freeing it from the moorings of

logic was essential in clearing the way for pure abstraction. This idea of his, this notion to use colour for its own sake and not make it conform to a truth about the subject, rather make it conform to the truth of his painting, became an essential element in the language of pure abstraction and in turn made Matisse one of the most significant painters of the twentieth century.

In the end I was too tired to enjoy the gorgeous landscapes of Eadweard Muybridge and the innovative images documenting people and animals in motion. It had been over four hours since I arrived at the gallery. I kicked around the gift shop for a while, looking at books and thinking about a toy for my grandson, and then walked out of the building into the bright sunshine and the hustle of the streets at rush hour. I ambled along and window-shopped and drifted home at a leisurely pace thinking about what I had seen and glad to have had the opportunity to spend a day alone looking at art. As an artist and a writer those days are always regenerative and images and ideas cook for weeks and months afterward often taking shape later in surprising ways in my own work.

20

Chance, accident, the spontaneous gesture. These are occurrences that can bring life to a static and resistant work of art. The surrealist artists incorporated spontaneity and chance into their work to free the creative mind and help tap into the unconscious, the new terrain they wanted to explore in the twentieth century after reading what Freud, amongst others, had discovered about the human mind. These artists were tired of conventional representations of the world around them and wanted to depict things never captured before. The great dream-like images of Dali, Magritte, Delveaux, and the otherworldly landscapes of Tanguy as well as the wildly free-spirited painting of Miró and the distortions and exaggerations of the human form created by Picasso, all came from this urge to work with the imagery of the unknown, to work in a way where the outcome was not predictable. There was a great deal to learn from the surrealists about an approach to creating work that was fresh and original, and there were lessons I tried to apply to the painting and the poetry I worked on years ago. These methods are still important to the work I do in the studio and I think having an awareness of this approach to making art has had a significant impact on the way I have lived my life.

In the studio last October I was struggling with a large painting. It had been days and days and I was hating the work and

on the verge of taking an X-acto knife and cutting it to pieces. Something was amiss. My sense of what I wanted to do and what I was doing were not in sync. Something rational, something conceptual, was guiding me and that was in conflict with what that work wanted to become. I resisted the urge to destroy it and instead took a trowel and a shade of grey-black paint and obliterated every element in the picture that I disliked. With the gestures of using the trowel and the shapes that came from those gestures, the painting started to move in a whole new direction. It was a breakthrough in my work and changed everything. Spontaneity and chance and using the accidental dripping and flow of the trowelled paint to develop the composition. Something happens when you allow yourself to work this way. Something subtle shifts in your psychic makeup and you develop a sense of confidence in your ability to make decisions. Sure there can often be frustration in taking a piece to completion having to find the route instinctively, but the resolution, if successful, is enormously satisfying. The way of art.

Acknowledgements

Along the way there was Robert Roussil sculptor, Jim Ritchie sculptor, Kazimir Glaz painter, Peter Mellen art historian and author, Winston Collins teacher and critic, Earle Birney poet, Mordecai Richler author.

Mark Sarner whose initial enthusiasm for *The Way of Art* kept the project alive, Kiloran McRae for a careful reading of the text, Janet Turnbull Irving for her thoughts about the form of this book, Claire Weissman Wilks and Barry Callaghan for believing in the project and supporting its publication, Michael Callaghan for his patient collaboration on the design of the book, and Sarah Agnew for her continued encouragement and insight into *The Way of Art* and for her love and friendship in our journey through life itself.

The author's photograph was taken by Jennifer Carfagnini.